TITLES
TO SELECTED SCULPTURES
1985–2018

JAMES MAGEE

Cinco Puntos Press
El Paso, Texas

FIRST EDITION

1

Library of Congress Cataloging-in-Publication Data

Names: Magee, James R., author.
Title: Titles: To Selected Sculptures / by James Magee.
Description: El Paso, Texas : Cinco Puntos Press, [2018]
Identifiers: LCCN 2018027163 | ISBN 978-1-941026-98-4 (pbk. : alk. paper)
Classification: LCC PS3613.A34274 A6 2018 | DDC 811/.6—dc23
LC record available at https://lccn.loc.gov/2018027163

This book is set in Mrs. Eaves, designed in 1996 by Zuzana Licko. It was styled after Baskerville, a beloved transitional serif typeface designed in 1757 by John Baskerville in Birmingham, England. Mrs Eaves was named after Baskerville's live-in housekeeper, Sarah Eaves, whom he later married.

Cover: Inspired detritus from the studio of James Magee,
Photograph by Christ Chavez, 2018.

Design: Anne M. Giangiulio

Thanks to Kerry Doyle for her generous commentary
on the life and work of James Magee.

TABLE OF CONTENTS

AUTHOR'S FOREWORD

BY JAMES MAGEE

These titles, as miniature dramas, accompany specific works of sculpture which I have made. I wrote them between 1985 and early 2018. I began writing titles to my work in 1972 when I was living—and beginning to sculpt—at the Lester Kehoe Junkyard on Staten Island. Many of the early titles were written as songs and were sung and recorded inside the giant milk containers strewn about the junkyard. In the mid-1970s I briefly attempted to earn a living by making small books of my etchings, and I would couple the images with my verse, which served as a text. Occasionally I would read these poems aloud to gay men frequenting the Hudson River piers at the end of Christopher Street in Greenwich Village, and usually this would be at night before a largely distracted audience.

Later, while working upstate at New Hope, a home for adults with developmental disabilites, I again wrote titles which took the form of monologues inspired by the residents; and soon these titles were obliquely attached to an opera project, i.e., the drawings which I had done for the Eastman School of Music. When the opera traveled to California in 1977, I was afforded my first trip west of the Mississippi foreshadowing a move to El Paso, Texas, four years later. More recently a number of adventuresome composers have used the titles as librettos for their music and three of the titles have been the subject of art videos.

Not all of my sculptures are given titles. Oddly for me, the pieces for which I have labored most have no titles...but when a title finally does appear, it may happen two or three years after the sculpture is complete.

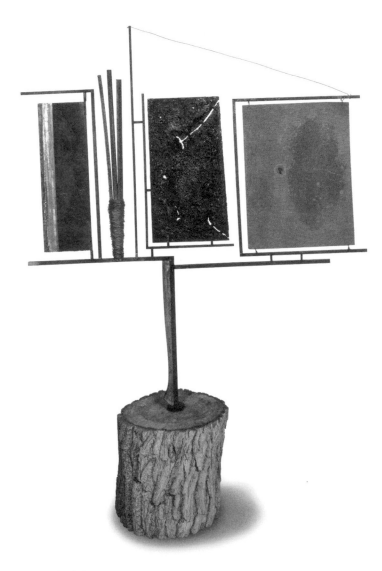

Juan's Ax, mixed media, 51 5/8 x 35 ¾ x 3 inches, 1997.

Juan's ax aches.
His tracks lead backwards.
He takes another swing
at the boat floating on the lake,
his wife and kiddos
sailing by too fast
to ask why.

Without an excuse a sealed flirtatious 40-foot square room

filled with 127 adult males

would produce in a 24-hour period:

43 cubic feet of methane gas;

11 gallons of urine;

38 pounds of feces;

pump 128,000 gallons of blood;

yield 3 ½ yards of protein in the form of hair;

9 inches of protein in the form of toe and fingernails;

3 quarts of semen;

and 9 buckets of perspiration.

Without exaggeration or risk of castigation a dark 40-foot square room

holding 127 audacious males would produce in a 24-hour period:

20 fifty-gallon drums of passion,

as in the random motion of 254 anonymous hands;

78 yards of yearning burning inside my ear;

42 bushels of fear consorting near a locked door; and what's more,

only 2.4 pounds of devotion snared in a weir

beneath a bent ocean skinned over with tears.

Florence scrubs her hands with a piece of bark.

 From a distance the woodman yells:

 "I heard him rolling down the hill

 eroding his brown-laced shoes on a bed of stone,

 sleeping alone through the rain, nothing seeming the same anymore,

 his feet coiled around a green fish ripped from the river bottom!"

Standing over a frying pan, Florence sings of a day lost in a park.

 In the distance the woodman howls:

 "I held him by the toes,

 Lord knows a young man with a good heart

 and fine brown hair

 floating downstream past a cliff,

 a jar of soft wax

 and an uprooted tree along the shore,

 nothing more!"

Moving towards her nightstand

 Florence pauses to catch the words torn from her side.

 At a distance the woodman wails:

 "I felt his thumping in my chest

 headfirst over a small shrub.

 It was a quick ride,

 then there was a splash

 or maybe it was a log from high above,

but I know it was him on the river!"

As best she can, forgetting the bark, the pan,

the light left burning on the stand,

Florence beds down in her house, hurting, knowing too well

that the molding around the wainscot in the dining room needs dusting;

and then she yells back:

"Kerry left me a trench behind

and a boy wearing a blue sailor suit

up on the rooftop click, click, click.

Last night I saw him suspended high above Mother's apartment.

I knew it was Kerry

from the pink softness of his feet.

We begged him to descend before the plane started to bend

when Kerry began to fold his dress shirt

together with my summer blouse,

mistaking our canvas suitcase

for the blue canopy covering our neighbor's pool,

too cool last night for anyone to take a plunge.

So Kerry fearlessly ended what the night had begun:

diving into the vase on the kitchen table saying,

"We must save face.

This is not the river, Florence,

and I will never be your woodman."

I remember you standing on the dock in the breeze, David,

white clouds behind you,

your blue and yellow shirt billowing,

and how you peered uneasily into my camera.

Since then, for the past three years I am afraid,

the dunes have been drifting steadily westward,

swallowing tables and chairs, advancing on forest and field alike,

slowly erasing all roads leading out from here,

so that now even my mouth and ears are packed with sand.

Nearby, the last approachable inlet, at least by foot,

is breathing below the surface,

where you are pearled among seashells.

What little water remains, David, drains into this inlet.

What fish remain swim among its reeds

farther and farther from the open, vanishing sea.

In the distance a boy, whose family moved here after you had left,

walks along what was once Quarterline Road looking for his tree house.

But the tree is gone, along with the road, and he is angry.

This morning, as with every morning this past week, he dug me up

and strapped me spread eagle across a car hood

nearly pulling my arms out of their sockets;

and then snapping my arms back, like the tongue of a Jew's harp,

he knocked me onto the ground, laughing.

I am uncertain, David, as to how long I can endure.
Soon I hope the plumber's wife—and you must meet her—
will free me from this boy.
She doesn't live near the inlet and rarely comes to bathe.
She lives with the plumber where the grass still grows green
on the other side of the bay.

Once she discovers me, she'll pull me out of the sand
before the boy returns,
 and gently lying me upon the ground,
 she'll cut open my heart to empty it
 of its millions of tiny sand granules.

 Later the plumber's wife will carry me back to her house
 to sit me in the middle of her vegetable garden,
 instructing her husband to install
 a circle of drain spouts above my head
 so that I might water her carrots and tomatoes.

But next door to the plumber's wife,
 and this is my problem, David,
 lives another woman who is constantly paving over her driveway.
 This other woman is the boy's aunt
 and she'll alert the boy to my living in the garden.
 This other woman speaks in a language of walls and corridors,
and is constantly dragging a knife across her kitchen counter.

I tell her the scraping of the blade makes me shiver.

I tell her to stop.

But her scraping grows louder

and she pays for nothing.

Now the wind is picking up.

Shingles are blowing off the plumber's roof

landing haphazardly onto the yard

next to our row of tomatoes.

I study the shingles

looking for patterns of a world as it should be.

I examine their tears and broken edges,

how one shingle lies upon another,

how a road or maybe a path within its design

might lead me back to a decency

not yet reduced to yes or no.

Tooth

speaks to me
each morning.

The sheets fit.

I'm in an old country house
eating my breakfast
of toast and cereal.

Outdoors men dressed as Swedish farmers
are falling down on the other side of the road
near a cold river
calling out to a boy, my grandfather,
to fetch his hoe,
for Jacob, his own grandfather,
wondering the woods last night,
slept in too late
and forgot to till his field.

Tooth says don't yield to others.
What once was joy became toil.
Jacob's healed of turning soil.

FIRST BOY: No kidding, last night in the back of the black spot of my eye, way back,
 I see this old coot in a drain ditch float'n around in an inner-tube,
 revolv'n dark and watery.

SECOND BOY: I seen him, too, but he wasn't in no inner-tube and he sure wasn't
 float'n around in no drain ditch. He was roll'n down the dirt road
 in back of the tin church in my wagon holler'n like a high-pitched
 woman, yes, yell'n St. Ida this, St. Ida that, never had a good ass
 to begin with, too flat, too flat...and I tell ya that wasn't the first
 time I seen him back there with his arm hooked up to an i.v.

CUT TO A WET SUMMER NIGHT IN AN EASTERN CITY OF RED BRICK: Older
middle-aged man sitting alone among tall leafy trees near an empty parking lot, a silhouetted
steeple behind him; and then beneath his breath he begins "gotta clean up, gotta clean up,
gotta clean up your own yard first, gotta goat, gotta goat, gotta gotta goat, gotta clean up, gotta
clean up your own goat first, gotta, gotta goat gotta clean up, gotta, gotta goat gotta, gotta, gotta...

AND THEN THE MAN, HIS FACE SMEARED WITH LIPSTICK, TURNS TO ADDRESS
AN AUDIENCE:
 "Sometimes when I'm out here like this near the drain hole,

 and I'm drawn to holes no matter the day or night, or year, for that matter,

 especially if they're whole sucking soul holes,

 I begin to see light exploding from trunks of trees,

spark like stones struck together brighter than a sun uplifted,

because you see I've been slithering around on this wet ground on all fours

for so long now that the trees and me,

we kind of understand one another in the gradualness of our less and less,

as in the meaning of a puckered-up lip

or a twitching eye

or an oar digging into a pickled lake, no matter the why,

like I'm beginning to think maybe my meat must be slipping away from my mind drip by drip,

leaking southward toward my throat

passing through the stem and the stern man,

probing the hair around his armpit

and the warm spit in his mouth

slushing around his scrotum and over his toes,

the smell of night, say, after a rainstorm near my soul;

and then, by God,

right when I'm in the middle of drinking him in,

she'd walk out again from a dark corner

into a full view of Delft between 13th Street and Little West 12th,

a large, 17th century Dutch woman

carrying a basket of breaded chinaware along a canal,

droplets of sunlight touching the Protestant steeple behind her

following a brief shower near the meat district;

and we, seven or eight of us leather boys,

kicking up our heels

and sniffing the spill on the second floor along the shaft

would hope for more in the back room near the tub, bub;

but that damn charwoman,

Jesus, if she wouldn't keep trundling through

as though nothing were happening around her,

rattling on in her lowland Dutch,

splicing together those guttural vowels beneath the bowels of 832 Washington Street,

her blue and white clattertrap,

her broken china of Delftish boys

wearing wooden shoes strapped to rubber toys,

pants pulled down,

ricocheting from wall to dark wall

only to fall by cold sunrise,

our cocks aching,

into the Hudson River."

Night pours down on a rented room

wallpapered in last week's sports section.

Miguel, practicing his own school of dissection,

slowly pushes the vase nearer to the window sill,

murmuring hour after hour:

"Still I need someone to come home to;

my work is confusing, like you, Corina,

soft and dark, your black hair falling over your shoulders,

the southern mountains breaking up along the highway,

the night filled with shining boulders;

I want to build you a wooden house a few inches from the vase,

a small house to be sure,

with a table under the table in the dining room

and a record player that works.

But you keep telling me to get out of bed:

'Clouds or no clouds, the cats must be fed,

and so must I, my apple pie boy.'"

Bear down on it

or tear it up in anger.

Yet who owns this hillside house, anyway?
Does its occupant have clear title?
Is he a drug abuser?
A user of children?
Should I buy a taser?

Then Jordon, scratching himself,

motions to me to climb again into his boat,

saying, "We must get back

to the other side of the river before dark."

And I sit down on a seat next to him,

my leg brushing up against his,

and I fall asleep, my head in his lap.

"We must return to the city," Jordon repeats.

"We must return to the city,

where unfinished high-rises

stand mostly empty

without indoor plumbing or electricity,

where children play unsupervised in the streets,

where their mothers' laundry, scrubbed with sand,

flutters high above on ropes

strung between the buildings,

where a man with perfect memory

sells wire springs."

And upon debarking from Jordon's boat

I see that this spring salesman is tall and thin

with a salt and pepper beard

and that he is Jordon's friend,

saying he remembers me from years ago,

that he is happy to see me once more,

and I smile back at him,

pretending I recall the moment,

but embarrassed,

because I'm wearing no shirt.

(Of) three boys

Sunday winter walking,

roses blooming in their pockets, laughing low

no sneakers cooler than mine, asshole.

—Better whiter than redder, goat head.

—Better ever than never if ever whiter than blacker on the fifth of December

I ride the bus for my father trying to see King Street as he once did;

and for my mother, frail and aquiline, even before her illness,

I slowly pass the schoolyard where she had played in a child's innocence of long ribbons.

Birds fall from the clouds.

My grandfather stands in the doorway,

his anger compressed into hand grenades

stolen from steel boxes rusting on the curb,

their pins still in,

poorer now than the crockery

he peddles in the marketplace on Saturdays.

———————————————

Across the street the Hansons gather up their tablecloth,

along with their child, Morley, barefooted and runny-nosed,

who from the first day, my mother would say,

was stronger and wiser than the room into which he was born

or the hands that held him.

—A light unto the gentiles, she whispered.

Lead hot red corpuscles running in torrents across the blue frosted sky

seeping into the cracks of their mud walls

 and into their veins, hotter, then colder, then hotter,

their night beds pressed up against the heater,

 geese squawking,

 Morley's rooster crowing backwards from dusk to dawn,

the whole town snoring, waking, tossing, turning every fifteen minutes,

 eyes half-open halfway through the cockadoodledoo.

Morley said not to fret,

 for we are little more than membrane,

 a thin tissue through which light passes for but a moment,

 an eye gazing into an eye.

—Purpose?

 —No purpose, he said.

 —Justice?

 —Just luck…a matter of throwing the dice.

————————————————————

Over fifty treadless tires are piled on top of my roof.

 Morley hauls them up there to keep my tar paper from blowing away.

 He says old tires make good stairways, too,

 just fill them up with dry straw and mud, or better still, cement.

Tonight men are gathering near the wall in secret to decide the fate of Morley's rooster.

 "It's eight feet tall," one of them claims,

 "the biggest damn thing you ever did see,

 rolls along on feathered wheels,

 lightning bugs pasted to the side of its head,

 a regular lickety-split of a Second Coming,

 a real cockadoodledandy,

 and it scares the living daylights out of my kids.

 They can't sleep at night."

Morley believes each of us is only a variation on the same theme,

 a viral dilapidation of a vaccination stuck into an arm of a giant millions of years ago.

 "Go ahead, pray in church.

 Count your fourteen stations, if you like,

 or his T-Cells for that matter,

but it won't bring back our boy,"

I heard Morley tell his wife one night.

"Just don't tear up the carrots, love,

peel them slowly,

and before you turn out the light

on your side of the bed,

give me a little squeeze, please."

A single point of light

 imperfectly framed

zipping by my fly:

 and I, understanding nothing,

 but the smell of it

 connecting belly to brain.

A row of summer maples in the foreground.
In the background, five high-rise apartment buildings
from the nineteen thirties and the forties
surrounding a well-manicured park,
on the south side of which are eighteen blue and white doors
each leading to a modest one-story dwelling rented by the poor.

A bearded man, I shall call him Hersh, who has lived for decades behind one of these doors,
shows me his basket filled with mulch and a single gladiola bulb
he wishes to plant under one of the trees lying at the edge of the park.
I reach into the basket and grab the bulb wrapped in a napkin and it feels soft and damp.
Then Hersh smiles and says he is dying of throat cancer,
but that he would be happy today if only he could plant this bulb.

> *Day flips upside down.*
> *The apartment buildings disappear,*
> *As does a giant living a thousand miles away from here.*

Now I am sitting in my garden in the middle of a desert
where lie the delicate surfaces of my childhood.
Hersh stands near me watching a dove
perched at the edge of the bird bath.
Athena, exhausted and drowsy,
rests against the stone wall, her shoulder chipped,
her face covered with moss.

This is a world of imperfection and decay.

This is a world of invisible seashells.

This is the world I trust.

On the other side of the wall a woman pines for her giant to the east

and the giant aches for her,

but both know that he, without wishing to,

would level her into nothingness

with merely a glance,

and for he is Lord of Quasars, Pulsars and Black Holes.

Day turns back into night.

Now Hersh barrows along a dark two-lane highway,

hope gone bad,

a silhouetted mountain ahead,

no moon,

no room, just a few stars

separating him from the Museum of Forgotten Prayers

standing abandoned several hours east of El Paso.

Graffiti covers its walls.

33

The roof of the museum slides backwards,

digging into a set of small concrete chambers

lying to one side of the main entrance,

while scraps of paper, each holding a request,

blow about the floor with the tumbleweed:

"God, will you take care of grandma?
Her belly is sticking out too far!"

"God, please fix the jitters on the TV!
Please! Please! Before the Super Bowl begins!"

"Oh, God, make Billy Cardwick fall in love with me...
and what about my pantyhose...?"

and next to these chambers lies a much larger asymmetrical room holding

all the unanswered, collective prayers belonging to history,

including those of the Girl Scouts, the football team, the men's church group,

and those of the nation

fearful of the threat from within.

The highway to the museum soon disappears.
Hersh no longer sees the center strip
and the car ahead is moving too slowly.
Then Hersh pulls into the oncoming lane
and suddenly headlights bear down upon him.

A crash of steel and glass.

All goes black.

No sound.

No feeling.

No breathing.

No cares.

No prayers.

Only a crack of light.

Then nothing.

Night changes into day. The desert drifts away.
The tall apartment buildings and the green park return.
It's late morning.

A young couple, after spreading their blanket upon the ground,

lie down to sun themselves on the west side of the park.

From afar I watch Hersh

walk towards a tree to plant his bulb.

After scooping out a long trough with his hand,

Hersh then takes the bulb from the basket

and places it into a tuck behind his heart

in memory of speckled bugs.

Then the bearded Hersh lies down in the trough

beneath a tree not far from the street,

and covers himself with a few inches of dirt

to keep at bay the morning heat.

Mending the Cosmos: three attempts...

For Mario, watching sparrows atop a telephone pole:

> I've fathered seven children.
>
> Three have done well.
>
> Two are dead.
>
> One's in jail.
>
> One's disappeared.
>
> Still after sixty-six years
>
> I've a full head of hair
>
> and a Lazyboy chair in the living room.

For Julie, rubbing her nose not knowing why:

> So I'm too old to bear my own.
>
> I clean tables.
>
> I dread going home.
>
> Do I need a man?
>
> Sure, maybe like Bruce, a real mango,
>
> But I'd settle for less,
>
> I guess.

For David, pushing around a mound of dirt counterclockwise:

The best I can say is the boss
frustrates me at every turn
and now my lover of six years
rarely returns my calls.
What can I do?
I crawl on my knees
to listen to bees
hoping to hold back
the chaos.

I stir my coffee

as Friday morning turns into a memory of aching knees.

Mom keeps complaining of blood flowing unevenly across the window,

blending into my fear of it actually happening.

Still, as I rock from side to side,

I'm unclear about her layering the table

with these damned feelings:

a hat without a head I don't understand.

Now my ear is a cup bobbing up and down upon the waves.

It's finally night.

I'm on the ocean.

I'll try to sleep.

Far off through the haze I see a shore

strewn with apples and fallen vines

where almond-brown boys, riding bareback, linger, then disappear.

Orange...

Give unto others before

the ceiling collapses about you in the turn-around room.

Pork upon pork.

My thoughts bake.

Outside a car idles near the curb

as

July lies helplessly in a pile of twisted knots.

We, the scrambling chimps of this world, the nipping hyenas,
would be better off simply working together in one immense intergalactic whorehouse.

Most of us would be plumbers, accountants and ticket takers,
a few would play the piano
in the ten-thousand room palace carved into the face of a mountain,
a place of pilgrimage for souls threatened by toads and free parking.

Do unto others as you would have them do unto you.

The young would caress the old, and the old, in turn, would hum into the ears of the young,

the legless would be tenderly lowered into warm baths, and

the bereaved would be reminded once more that there are no departures.

Blessed are the poor in spirit for they shall be comforted.

Together we would lie quietly on a 200-acre bed

and spread our legs for a stranger in order to destroy the strangeness between us,

but we would keep our prices low,

while his semen flows warm and sweat over the tables and chairs in the great bedroom

down the sides of the red-carved mountain and over the parking lot,

out into the rivers and great lakes and oceans of orange monkey love,

for, dear Jesus, as you well know, our oldest profession remains the most charitable.

Blessed are they who give of themselves at great risk.

Hersh squints through a crack in the stone wall

and sees a wild boy chained up to a broken-down car in the desert.

Then Hersh hears a woman yelling from a house 50 ft. away:

"Look Tom, I left ya some drink in the tincan."

And the boy, snarling, bends down on all fours,

like Son of Sam, to lap up the water.

Truth is no matter where ya move to people will get up and die on ya.

The woman

now turns to Hersh

complaining:

"We all live

on the same

charred rim

of a dumb idea

with scarcely

a breath of air.

Still, Dad

wants to dig holes

in the backyard

where the Buick sits

year after year.

Then yesterday Dad

tears down

our chainlink fence

to make room

for a dog run

for the fun of it,

but I don't think

his project

will ever get done,

cause we've

got no dog

nor ever will,

ain't even a hog

on this hill."

Salt pours

through a tear in the morning sky

onto our winter wood lot of evergreens.

Cold, yet too warm for a late December day,

ice on Fremont Lake begins to melt away

while a lone sparrow or it could be a wren

bears down on its own peculiar world,

at the far end of a field outside of town, where

five fresh recruits, guns in hand,

heads shaved smooth as alabaster,

stand still in a still frozen land

of snow and clay.

1st recruit: So cold last night I creamed my sleeping bag.

2nd recruit: Winter makes my eyes sag, like I had this weird dream

about these dog-tagged vets

millin' around in Ma's fruit cellar,

skin as grey as slate,

yet you could see right through 'em.

3rd recruit: Funny, I had a gem of a dream, too,

about a screen door swingin' on a hinge

south of some railroad tracks.

I wanted to go in,

 but when I looked down

 my boots and the ground

 were covered with rotting flesh.

4th recruit: Why in God's name,

 as little Jesus lies in his crèche,

 did we sleep out here anyway?

 Didn't any of you guys see that motel back in town?

5th recruit: Yeah, I saw it all tumbled down

 like it had been a laundromat once,

 so I said noth'n.

3rd recruit: Who the fuck knows,

 but what would you guess lies over there

 on the other side of the hill?

1st recruit: Not a clue.

3rd recruit: I feel in the skin of my bones

 there's an old woman in a white frame house

 sittin' near a stove this very minute

 worryin' about how her dress will rise above her knees

 when she gets up to pee.

4th recruit: Got cramps again.

2nd recruit: Then sit your sweet ass behind that tree.

4th recruit: No, I mean my legs, jack-off!

2nd recruit: Sometimes I swear

 I can hear the jars down in Ma's fruit cellar

 gabb'n all the words I've ever spoken,

 the good, the bad, the broken,

 I mean they're pickled in with the apples and peaches.

5th recruit: Think I'll pass on that one, soldier.

 But I know there's goin' to be a reckoning.

 Has to be.

 I'm try'n to remember our coach's name:

 Hadick?

 Hadwick?

 Harding?

 Shit, what I'd give

 to run a few good laps around the track

 or once more

 play a night football game in Squire Field.

 Hargrove?

 Harmon?

 Harlow?

 Hurley?

47

Christi,

 I can't remember.

 Harden?

 Hardwin?

 Harkin?

Sometimes yes.

 Sometimes no.

I take a bus

 I take a bus with stones for thought

 complex concave

from hand to mouth from snow to sand:

 a desert land of angry heat

 and shameless light

 where by day I build a city of night

 untempered

 untried

for a cross-eyed girl a bus stop girl

whose thin red lips and narrow hips

are yet too wide

to hide beneath my underside.

It may have been my fault.

I did make mistakes.

Yet I think it was impossible for Annie to reconcile

the cross purposes of our dif-

ferences.

Annie, this morning a West Texas sky, shaped like a knife, serrated the patterns of your dress

as you were hoisted above the rest of us on a river of white sand;

so that now I, too, am swimming helplessly among women

carrying bags of potatoes and pinto beans near a market filled with children's dust

with a broom for a boy with a toy truck and

and a can for a man with a cane.

I turn around.

I'm feeling dizzy again,

for earlier this morning before breakfast in a crowd,

frightened

broken,

I, too, came to fill in the trench we had dug last night

to bury your gloves among melons and pilgrims,

as if you were pretending nothing was happening back home with the chickens,

or last night that I had yelled at you from the back of the hotel

how good intentions spoil like cucumbers

if left out too long in the sun,

or that I would have ever come inside you without protection or worry,

(So don't worry, Annie, even if you're young enough to be my daughter.)

Then again later today, under the shade of a tree,

you cried out no matter what I had done

you would wear forever for me

as an act of forgiveness a head of red cabbage,

because I had promised,

or so it had seemed,

no more steps in the hallway nor rain on the stairway.

Anna insists
we build a basketball court
with a chainlink fence
to keep the ball
from rolling into the street.

But first
I need to split
myself into two.
I'll use old bed springs or
a stack of wooden crates or
a black bitch dog
dragging her tits
across the street.

Voices comingle.

I am forgetting.

Sleep absolves.

Above me hangs a clouded sky

held together with baling wire.

* * *

What I hope for most, Annie, is an electric fan

or a tub of cement to spit into,

a blue shaft eight stories high

boring right through me,

or maybe

a cone of cherry ice to suck on,

as if there were only one person left

in the marketplace near Cuauhtémoc:

a man within her,

a woman within him,

a child trapped inside the grandfather

soaring up towards a flock of birds…

and yet I can't help it.

I know I will commit the same crime tonight

by digging a new trench

beyond our western suburbs.

* * *

When I see you, Annie,
I don't know what to say.
I want to be forgiven,
But I hesitate to ask,
because you know
I'm a repeat offender.

Annie, what if I offer you a tree limb covered with old shirts and self-doubt?

 Please,

 hear me out!

 I'll give you this photograph

 of a woman carrying her baby

 (or is it a quart of transmission fluid?),

or what of a piece of re-bar,

 dipped in red and yellow paint

 and a view of a turquoise house near a cornfield;

 or, Annie, maybe an entire bank of rain clouds

 stretching from one end of the mesa to the other?

 Yet, even with these gifts, we both know it would not be enough to restore your eyes,

 or even a morning breeze blowing through a screen door.

THROUGH EMPTINESS

No Room for Gentleness on a Grease Monkey's Floor

Nor Elegance of Rain Falling

I, II, III

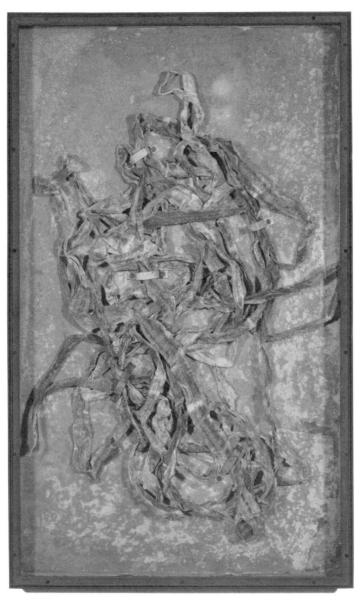

James Magee, *Mending the Cosmos*, mixed media, 51 5/8 x 35 ¾ x 3 inches, 2011.

KEEPING PEACE WITH THE GREATER ARMY of fathers & sons:

Without even trying

Dad was the third fastest half-miler in the country

until he broke his knee caps in a car wreck:

tall and broad shouldered,

headstrong,

armstrong,

leg strong,

honest as the day is long

after a brief shower,

Dad strides across Main in his new suit just

before supper

to sneak a peak into

Charles White's window,

while across the street

four doors away leaves falling

Mom preens herself in front of a mirror

barely remembering the chicken boiling on the stove,

confident good intentions matter no matter what,

though rarely mentioned

and then only in a whisper,

how on one cold, December night,

23 years before,

John Kern, Dad's partner in the dealership,

was found murdered in Detroit,

dumped naked in a snowbank.

What in the hell was that about? And naked?

Dad squeamishly pushes the thought away from him,

whisking it into the wastepaper basket

to the side of the desk,

in order to make more room

for all the unsold Fords and Mercurys

pilling up in the car lot.

"Yes, shadows can be healing,

but watch your step, boy," Dad would say,

"or this world will break you in two."

I know I'm not the son you had wanted, Dad.

Yet we made do.

I wasn't a redhead, like you, all freckles,

nor was I that good at high jump,

or catching a ball in centerfield,

poor eye-hand coordination, you said,

and more difficult still for both of us,

I insisted on poetry.

Many years ago,

no matter how hard we had struggled

to find common ground after I quit Little League,

we eventually parted ways over my lopsided imagination and

clay pots I insisted were strewn about

at the bottom of Pickerel Lake:

a heartbreak neither one of us could have prevented,

nor dared to recall.

In honor of your plainspoken decency, Dad,

and with words we once both feared,

I will fashion for you a mantra,

disguised as a clothesline,

repeating your name

every morning before breakfast

and again at night

until the end of my days, or

until you come home.

His bed is soft.

He falls asleep.

A torrent of fear tearing his sheets

flows southward flooding his thoughts

with stray cars, trucks, cattle and a hillside of sheep washed away

near Lordsburg;

and lost amid the darkness her head above the water

his Emma cries out for mother's chinaware

as the river changes course again across ranch land, an airport,

and a row of cinder block shanties squatting in the mud,

their windows broken out,

where a fourteen-year-old boy,

his lungs filling up with river brine brown eyes once blue now crystalline

sneaks out of his father's house

to crouch wet beneath a neighbor's tree

to watch the slumbering man turn over again at 3:00 am,

as the river rips through No-Money-Down-Used-Car-Lot-Town;

and the boy with a frown of dark water and his father's knife in hand,

moves his liquid haunches a bit closer to the window

to hear the sleeping man mumble half consciously:

"Grass smells good after a rain."

Three Days Later on a Bus Racing Towards Chihuahua:

The boy, barely able to speak Spanglish,

snaps at an old Connecticut woman

stumbling on an empty Coca-Cola bottle rolling

towards the back of the bus.

The woman trips over the bottle

and grabs a seat, responding:

"Best watch yourself, sonny.

Soda has no nutritional value at all.

Just piss it away, like me, too far gone for a singsong,

or even a pile of bones

left along the side of the highway."

A cigarette dangles from the boy's lips.
A cumbia plays over the radio.
The boy flicks his ashes onto the floor of the bus,
and turns to the woman saying in Spanish:

"Dont worry, old gringa,
 I see my grandmother in your face.
 Mi abuela left me Father's belt and this knife, too,

and told me that night falls evenly on all living forms,

young and old, weak and strong, rich and poor."

The Yankee woman pauses.

She is struck by the measured tone of the boy's remarks,

but understands nothing.

She thinks back to a lover she once had decades ago

and how his eyes are now closed,

a doorway and two windows alone in a field,

my love sleeps by my side,

quietly he breathes

and his twitching is vulnerable to the earth

when the night wind ruffles his hair.

She thinks again:

Once I could hold my children and know they were mine,

but now they scarcely visit me at all,

and when they do visit,

they bring their own ratty children,

who only want that cup of blueberries on the top shelf.

She thinks again:

Why are Max Morrison's apple trees covered with netting?

To keep the black birds away?

And why does he bind the back legs of that colt?

Oh, to be a wild animal once more,

sixteen or seventeen years old,

or I'd settle for the gentle face of a farmer's cow

sleeping under the stars,

the rain and sleet beating against my fur,

my bones aching with dampness,

my hooves encrusted with mud;

And then to awake at sunrise

with God in my nostrils and dew in my eyes;

I mean it was only yesterday

with white puffs of cotton tumbling across the sky

that I rubbed my hands together,

and before I knew what I had done,

a thread within the tapestry of the Universe was gone forever.

And so it had been with him,

tall and unbroken,

silently entering my bedroom

and turning out the light,

and with hands that soon would know me,

he would quietly untie the laces of his shoes.

I'm all tangled up < --- --- --- --- --- - --- --- -> in my bedsheets.

Can't get a bus (out of here)

Just squashed a cockroach splat in my dream,

and then I think of the smell of hair

burning

in *Uruk*

or so it seems for no good reason

people are fleeing everywhere.

Again this evening I'll stand outside my door

 until you return in whatever form.

Yesterday morning on the far side of the lawn

I saw twelve bronze heads emerged from beneath the grass,

each on top a granite base five feet off the ground,

each of a man, eyes cast up or down,

with blood pooling about the third statue from the left.

 After these heads appeared

 I saw you for the first time, I swear,

 perched on the weathervane

 above the garage,

 unable or unwilling to speak to me,

but understanding how quickly morning

 can turn into despair

 should a bird become too fearful

 for the lightness of its wings.

 Now Winter's finally gone.

 Mud everywhere.

 And You're still here

 playing Hide and Seek.

 In a few hours fresh blood again will puddle

 about the base of that third statue to the left.

 and as was the case last night,

no doubt, like a fool, I'll race back and forth across the yard

 With a roll of bandages and disinfectant, too,

 to try to nurse its wound.

 No atheists (live) in our town.

 I've told you that before;

 and the lawns are always mowed.

But damn it,

 if only you would speak!

 Just a word!

 To me!

 Even to statues that may not exist!

To houses along this street,

 waiting,

 always waiting

their storm cellars

 piled shoulder high

 with old beliefs!

Night descends:

The red tile roofs of Troy are covered
 with nesting birds.
Helen, her left leg swelling, lies in bed complaining of a sore throat,
while 300 yards away beyond the city walls
 Mycenaean troops lull about their campfires,
 each man lost unto himself
 after a cursed day.

 Unnoticed, dazed and alone, General George S. Patton,
 far from his family home in San Gabriel, California,
 stumbles out from a grove of poplars into the Mycenaean camp
 brandishing a swagger stick:

 "Where are my GI's," barks the Californian,
 "my own goddamn Third Army?"

 No one answers.

 "Have my boys forgotten their oats!"

 Not a soul replies.

"And what of my ivory-handled pistols?
I had them strapped to me earlier…
For Christ sakes, in a few short hours I'll need 'em
to blow off the heads of some of you tweaks!"

Not a word from the Greeks,

as Aletes, a Mycenaean foot soldier,

sitting a few feet away, stares into his own shadow fire

past Achilles' ship anchored off the Trojan shore glowing in the west;

and still more to his wife, Eirene,

not seen for three long years,

but in a dream she walks by a mangy dog growling in an alley:

weed to rock
tree to node
turnip & toad
hopping by

"And so what am I," asks Aletes, "to make of this dark mountain
rising before my fire and within me?
 I swear, it wasn't here at dusk
when we cleared the battlefield of bodies."

Helen's leg throbs.

Turning over in bed

 she shoves a pillow

 under her head

 and munches on an apple, musing:

 "If honor be of truth and courage,

 what then should I esteem above my beauty,

 but a ruthless buck so hard and hot each night

 he hurls himself between my legs

 to appease my twitching appetite

 for anymore of these boneheaded gents!"

Aletes closes his eyes

 and drifts away.

 The night digs deeper.
The Sun relents.

"Where in the Hell is the mess hall!" yells the Yank,
"Gotta have my coffee,boys!
Got kill'n to do tomorrow!"

Tonight a cold rain falls on Tucson.

Under an overpass I see you standing stark naked, Juan,
 headlights streaming by,
you toweling off with a wing of a blue and yellow bird
 found moments ago near a storm sewer,
as if water were confessing of white tile,
 where earlier you had imagined yourself as a bearded ancient,
 a Mesopotamian Lord kneeling down in the wet grass near the freeway
 to sing to an open field.

Guttersplat

spliced thrice

in a cackle cart

on a grey day

in the city

they say

'tis better

to split splat

a crackle cup

or a gutter plop

on the sidewalk

than to love twice

a kitty cock.

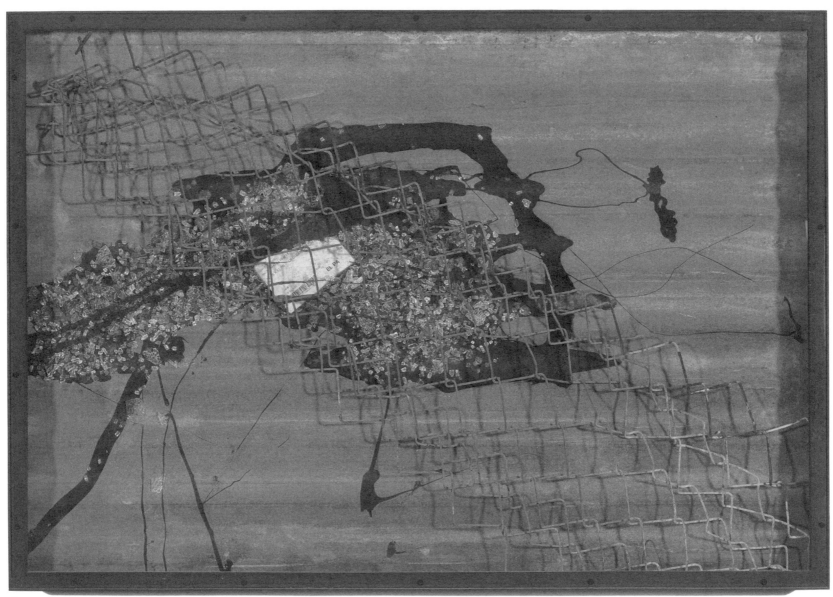

James Magee, *I Placed the Stone*, mixed media, 51 5/8 x 35 ¾ x 3 inches, 2014.

I placed the stone burial mound too close to my master's church.

> How could I?!

I dug the hole too shallow.

> How could I?!

I buried the dead horse in the hole.

> How could I?!

I mistook ornamentation for harmony and simplicity for stupidity.

> How could I?!

I overestimated the worth of my labor.

> How could I?!

I expressed indifference to the plight of my sister
and to that of water.

> How could I?!

Vanity, vanity, vanity all the world is vanity!

> How could I?!

A field of stone encircles my day.

Sometimes in the summer after supper I take a walk out back;

and now in my fifty-third year

a "just about" seems more like an "almost" than a "maybe."

Beams of light sift through the clouds.

Night shadows fall before me

as my legs wander off the edge of the field

into an irrigation ditch on the left side of my head.

My son said he lost his bike down by the river.

Claims that youngster Billy Ross took it.

But I know he stole it from himself

to buy more drugs off the back porch.

And the wife, and I do love her,

she says to me, Hartley,

we're near out of clothespins.

The wind's too strong to hang wash on the line.

When are we going to get that electric dryer fixed,

along with the book of poems you've never written?

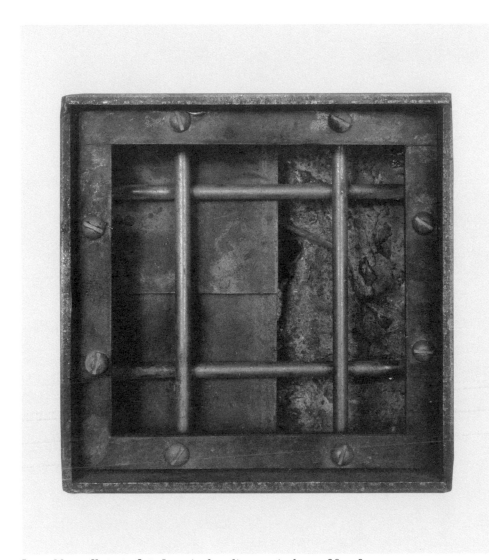

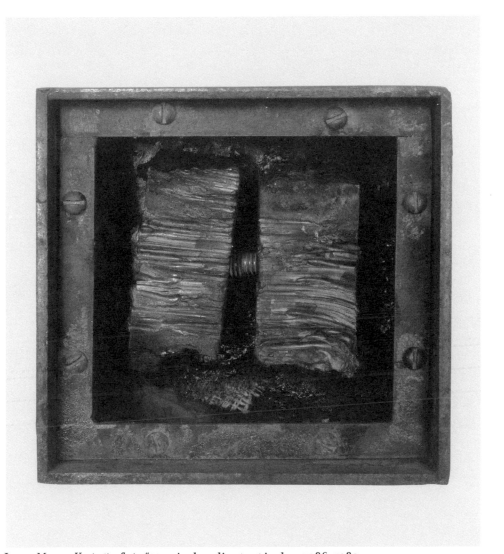

James Magee, *Vaccination Series #11*, mixed media, 4 x 5 inches, 1986–1989.

James Magee, *Vaccination Series #23*, mixed media, 4 x 5 inches, 1986–1989.

FOUR HUNDRED YARDS 'TIL MORNING:

I am dissolving into a landscape of half-light filtering through pine boughs.
Shallow lakes collect in the crevices of my back near my neck.
My hands have become as ridges along a mountain pass
and when my legs move—the heat is too much now—a pack of timber wolves
ceases to exist between the river and the plain
edging up the side of my bed in fire.

I am Walter at 104 degrees Fahrenheit
floating above myself north of Sault Ste. Marie
north of my father's fishing camp;
north of Lake Superior;
north of the hallway off of the doorway.
And I am Walter's son stumbling across a desert without memory
south of everything I have known
sucking on yucca and prickly cactus

years before the bridge was built.

I push the pillow under my arm.

Then it falls to the floor again.

The walls of my room breathe in and out.

They are my lungs now.

—I want a glass of water, Mother, another pill.
—But I gave you a pill five minutes ago.
—Please, Mother, I'm cramping up again
and the child hovering above my bed
keeps telling me to drink more water.

Twelve years later I am staring out of a window
upon an unfamiliar city before dawn.
I feel men stirring.
I smell their wet hair and touch their thighs.
A white liquid flows languidly beneath the sidewalk.
Below me a middle-aged, shirtless figure,
with a large birthmark on his back, bangs on a shop door.
No one answers.

Then a gang of marauding teenagers passes our hotel lobby.
One of the youths unzips his fly in front of the bellhop.
The bellhop blushes and turns away.
Across the street, directly opposite my window,
travelers from the south, I believe from Torreón,

are attempting to share a room.
I pretend the taller man is shouting at the other two.
I continue to watch until the youngest of the three,
a curious red-headed kid in a blue and white checked shirt,
notices me and pulls down the shade.

Too many trucks loading and unloading, Mother,
too many plans.

Though I know it's unfair
I reach out to feel
for Father's shoes under my chair, anyway,
and to close my eyes
to the morning meat cutter's song
slicing up my unfathomable timber wolf
into smaller, more edible portions.

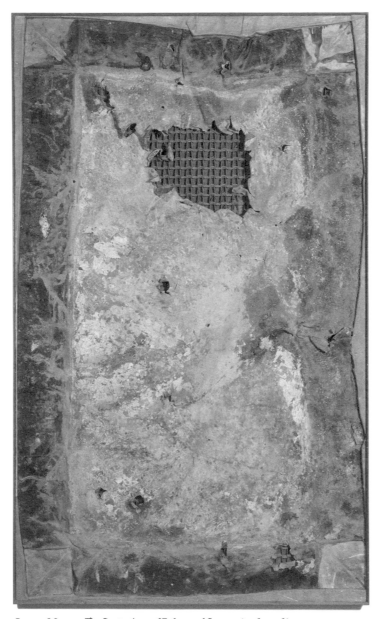

James Magee, *The Greater Army of Fathers and Sons*, mixed media, 40 x 66 inches, 2010.

Today is paradise overcast.

 A breeze blows past me as you, breathless, hurry out the door

spreading riddles among the tracks you left behind in our driveway.

 And near the field I've seen it all before:

the sheets of glass, thin wafers of time

 gathering together from within the Beginning,

so dim a light, four or five thousand years across

 lost at odd angles to one another

floating above a sea of alfalfa north of the highway near Dell City;

 and there beneath a sky drained of laughter, void of pity,

you sit, my Louie, on your tractor forever smiling,

 your deranged motor running, soon to sow another row of ditties,

your mother's songs about what went wrong with her children's children,

 so loud you sing no children has Louie,

that the grass bends over near a swirling eddy,

 a dust devil spiraling down from a cloud,

a restless day, a rainless day…my teeth feel gritty.

 You begin to sing.

You begin to pray.

 But I'm not ready…I'm never ready

Louie's song:

 "Judgementa Insecta am I

 Diptera Coleoptera, Lord of all praying mantises and mayflies,

 butterflies, dragonflies, houseflies,

aphids and thrips by the millions of gillions
of red ants and black ants,
henceforth to be known throughout my realm as
termites isopteran moptera ad infinitum.

"I, Grand Patriarch of the West Field of Hudspeth,
bow down in servitude to all living and dead
short worms, long worms,
wiggly worms and night crawlers;
to all hornets and wasps,
honeybees, bumblebees,
fishflies and styops,
locusts and gnats,
cicadas and crickets
by the umptillian of zillions;

"I, Lord of leafhoppers, ladybugs,
bedbugs, stinkbugs,
black beetles and boll weevils,
louse and lice;
I, Willful Believer in the Weaver of Light,
spin into a canopy of symphonies
all celestial centipedes, mantipedes,
mosquitoes, magpies,
apple pies, cherry pies,
peach pies, lemon meringue pies,

for my eyes have eaten of the crust,

nothing is left on my plate,

lust unto dust without dismay

as the Sun moves across the sky this day

singing above the maddening swarm,

so that out from my hairy legs

springeth forth a buttocks

and a grove of tall Elders,

as does the Earth re-enter the Earth

and the waters rejoin the waters,

so does my fear flow backwards into my groin as

I supplicate the smooth roundness of your grace

and the soft curve of your forgiveness

so that dare I praise our stained bed sheets

even as the floodgates burst forth

unto the morning fury unbuttoning my shirt,

unzipping my fly, untethering my belt,

melting into you, my mother

of Matthew, Mark, Luke and John

forsaken by a fifth lover,

recycled by a sixth,

legs spread eagle,

mouth open,

ears unplugged,

your plump, pink bottom
splitting the sheath of my barstool.

"I, Louie-Lou-I,
repentant, repaired beyond all confines
and by thee, my holy moley tractor,
bleeding the Earth with your blade,
I know that in licking your song
my tongue has sung no wrong."

AMEN.

James Magee, *My Ear is a Cup Upon the Waves*, mixed media,
16 x 44 inches, 1998.